Columbia
and the State of SOUTH CAROLINA

It's old with lots of new!
It's fun and friendly, too!

The places where you live and visit help shape who you become. So find out all you can about the special places around you!

Cool Stuff™

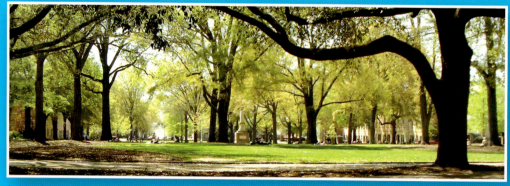

A view of part of the University of South Carolina campus in Columbia.

CREDITS

Series Concept and Development
Kate Boehm Jerome

Series Design
Steve Curtis Design, Inc. (www.SCDchicago.com); Roger Radtke, Todd Nossek

Reviewers and Contributors
Nicole D. Smith, Midlands Authority for Conventions, Sports & Tourism;
Connie Bodner, PhD, senior researcher; Judy Elgin Jensen, research and production;
Mary L. Heaton, copy editor

Photography
Cover(a), Back Cover(a), i(a), xvi(f) © Gabrielle Hovey/Shutterstock; Cover(b), Back Cover(b), i(b) © Yasonya/Shutterstock; Cover(c) © Perry Baker/SCPRT; Cover(d), *Marvelous Monikers* (b, d), xvi(c, e) © David McNamara; ii from Wikipedia.org; iii © Walter Keith Rice/Shutterstock; *Spotlight* (background) © Filipe B. Varela/Shutterstock; *Spotlight* (a), *By The Numbers* (a, b), xvi(g) Courtesy Columbia Metropolitan Convention & Visitors Bureau; *Spotlight* (b) Courtesy Columbia Marionette Theatre; *By The Numbers* (c) Courtesy the Columbia Metropolitan Convention Center; *By The Numbers* (d) © Ian MacLellan/Shutterstock; *Sights and Sounds* (a) © Alenavlad/Shutterstock; *Sights and Sounds* (b) © Marie C. Fields/Shutterstock; *Sights and Sounds* (c) © David P. Smith/Shutterstock; *Sights and Sounds* (d) © Doug Short; *Sights and Sounds* (e) Courtesy Columbia Metropolitan Convention & Visitors Bureau/SC State Museum; *Sights and Sounds* (f) Courtesy Historic Columbia Foundation; *Sights and Sounds* (g) © Jack Kozik; *Strange But True* (a,b), *Dramatic Days* (a) Courtesy Columbia Metropolitan Convention & Visitors Bureau/Nicole Smith; *Strange But True* (b) Courtesy Cromer's P-Nuts, Inc. (from the archives, circa 1940) Photo taken when store was located on the Assembly Street Farmers' Market in Columbia; *Strange But True* (c) Courtesy Riverbanks Zoo and Garden; *Marvelous Monikers* (a), xvi(h) © Leonard Vaughan/Cordsimages; *Marvelous Monikers* (c), xvi(a) © Jim Ferguson, Sandlapperstudio; *Dramatic Days* (b) by George N. Barnard, from Wikipedia.org; *Dramatic Days* (c) © Robert Muth/Shutterstock; xvi(b) © James Robinson/iStockphoto; xvi(d) © Daniel Hebert/Shutterstock.

Illustration
i © Jennifer Thermes/Photodisc/Getty Images

Copyright © 2011 Kate Boehm Jerome. All rights reserved. No part of this book may be used or reproduced in any manner without written permission except in the case of brief quotations embodied in critical articles and reviews.

ISBN 978-1-4396-0090-0
Library of Congress Catalog Card Number: 2010935886

Published by Arcadia Publishing, Charleston, SC
For all general information contact Arcadia Publishing at:
Telephone 843-853-2070
Fax 843-853-0044
Email sales@arcadiapublishing.com
For Customer Service and Orders:
Toll-Free 1-888-313-2665

Visit us on the Internet at www.arcadiapublishing.com

Table of Contents

Columbia

Spotlight on Columbia
By the Numbers
Sights and Sounds
Strange But True
Marvelous Monikers
Dramatic Days

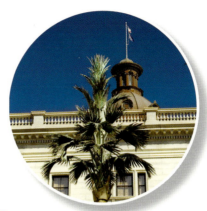

South Carolina

What's So Great About This State	1
The Land	2
Gorges	4
Beaches and Barrier Islands	6
Lakes and Rivers	8
The History	10
Monuments	12
Museums	14
Plantations	16
The People	18
Protecting	20
Creating Jobs	22
Celebrating	24
Birds and Words	26
More Fun Facts	28
Find Out More	30
South Carolina: At a Glance	31

Spotlight on Columbia!

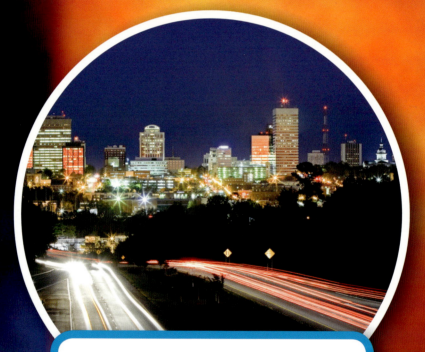

Columbia is the state capital of South Carolina and its largest city. It covers 125 square miles in the center of the state where the Saluda and Broad Rivers come together to form the Congaree.

Q: How many people live in Columbia?

A: The population of Columbia is about 130,000. But the greater metropolitan area (the city and surrounding area) is home to more than 740,000 people.

Q: Are there any sports teams in Columbia?

A: Absolutely! The people of Columbia especially love to rally around all of the University of South Carolina's Gamecock teams.

Q: What's one thing every kid should know about Columbia?

A: From its earliest days, Columbia's central location helped the city grow. A canal system (dating from the 1820s) and then railroad service (by 1842) kept the city prospering right from its start.

The Columbia Marionette Theatre honors the long-standing tradition of puppetry.

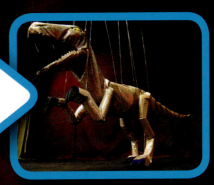

Spotlight

Columbia... By The Numbers

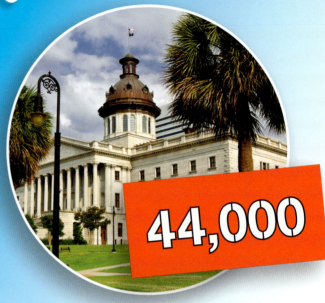

44,000

The exterior dome of the South Carolina State House is covered with an impressive 44,000 pounds of copper.

600

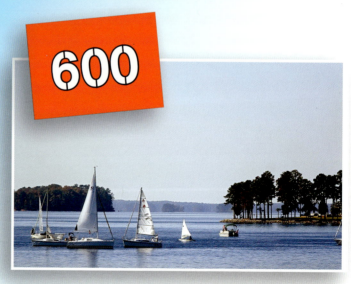

Lake Murray, which is close to Columbia, has more than 600 miles of shoreline. Boating, swimming, canoeing, and fishing are popular activities on the lake.

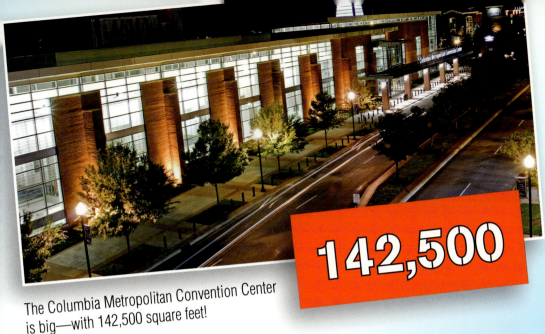

142,500

The Columbia Metropolitan Convention Center is big—with 142,500 square feet!

3

You can see three rivers—the Broad, Saluda, and Congaree—if you hike along the trails and boardwalks of the Three Rivers Greenway.

More Numbers!

1786	The year Columbia replaced Charleston as the seat of government for the state of South Carolina.
1801	The year South Carolina College (now known as the University of South Carolina) was founded.
1917	The year Fort Jackson (originally called Camp Jackson) was established. Today, it's the largest Initial Entry Training Center in the U.S. Army.

By The Numbers

Columbia: Sights and Sounds

Hear
...the wonderful music performed by the South Carolina Philharmonic Youth Orchestras. Any school-age musician from throughout the state can audition.

Taste
...the food at the South Carolina State Fair that's held every year in Columbia.

...some Irish treats at the annual St. Patrick's Day Festival in Five Points.

See

...Columbia's largest fire hydrant—which is really a huge sculpture called Busted Plug Plaza (done by local artist Blue Sky.)

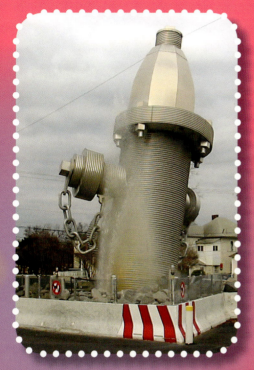

...the historic home of Modjeska Monteith Simkins, often called the matriarch of civil rights activists of South Carolina.

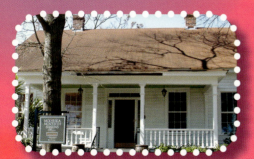

Explore

... the South Carolina State Museum. It has more than 70,000 artifacts—including an important collection of dinosaur fossils.

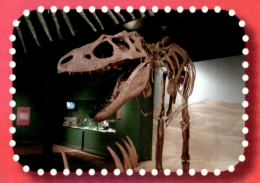

...the night sky at the Melton Memorial Observatory on the USC campus. On clear Monday nights, the public is invited to view the moon, planets, and any other interesting object in the sky.

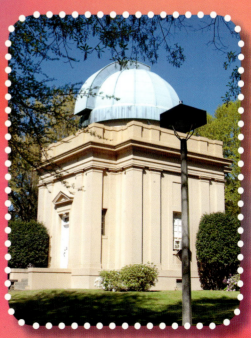

Sights and Sounds

COLUMBIA

STRANGE BUT TRUE!

THE EAST-WEST STREETS IN THE CITY OF COLUMBIA
The streets of Columbia running from east to west (with a few exceptions) were named for products important in the State's economy, for the two Taylor plantations on which the new Capital was located and for prominent individuals such as Gervais, author of the bill establishing Columbia as Capital.

THE NORTH-SOUTH STREETS IN THE CITY OF COLUMBIA
The north-south streets, laid out in the two mile square of the original city of Columbia in 1786, were named (except for Assembly) for generals and officers who fought in the American Revolution. Most of these were native Americans, but one was the Polish Count Pulaski.

NAME YOUR DIRECTION
When Columbia was first designed, city planners really had a plan! Many east-west streets were named for products important to the state's economy. Many north-south streets were named to honor generals and officers who fought in the American Revolution.

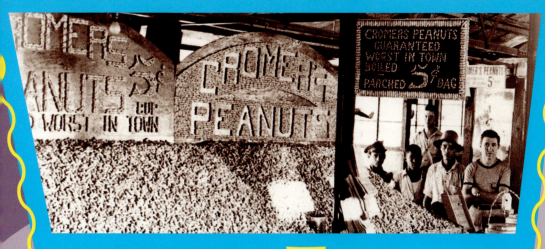

THE WORST IN TOWN!

In 1935, a man named Julian D. Cromer sold peanuts at his one-person farmer's stand. A competitor told people they were "the worst in town." Mr. Cromer wrote that on a cardboard sign and hung it over his stand—and customers flocked to him! Today, a much larger Cromer's store stands downtown, but its slogan is still "*Guaranteed Worst in Town*."

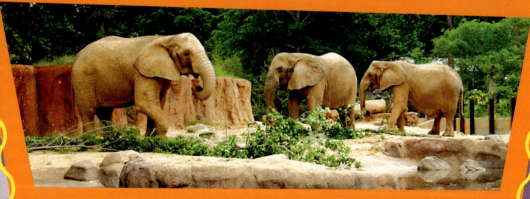

USING ZOO POO!

One elephant can produce as much as 200 pounds of poo a day! Luckily, the Riverbank Zoo's ComPOOst program puts the elephant (and zebra and giraffe) piles to good use. After a composting process, the animal manure turns into nutrient-rich (and odor-free!) dirt that can improve the soil in any garden.

Strange But True

Columbia: Marvelous Monikers

What's a moniker? It's another word for a name...and Columbia has plenty of interesting monikers around town!

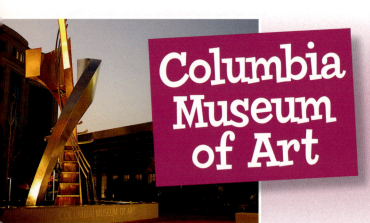

Columbia Museum of Art

An Artsy Name

The **Columbia Museum of Art** contains beautiful masterpieces. The museum's art education classes allow you to create your own "priceless" works of art, too!

Adluh Flour Mills

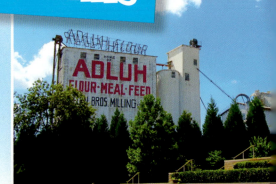

A Historic Name

Adluh Flour Mills, the last of the many flour mills that originally operated in Columbia, still uses milling stones to produce specialty grits—a southern food tradition.

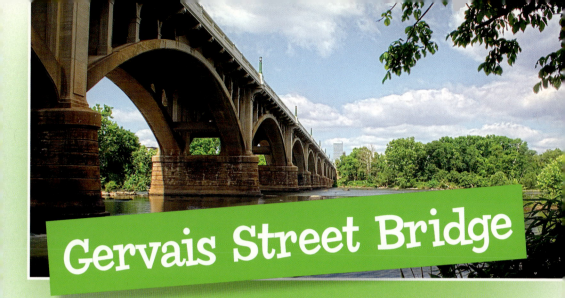

Gervais Street Bridge

A Connecting Name

The **Gervais Sreet Bridge**, completed in 1928, is Columbia's oldest bridge. It spans the Congaree River and connects West Columbia and Cayce with downtown Columbia.

Finlay Park

A Name for Fun!

Finlay Park is a beautiful 18-acre park in downtown Columbia that has a waterfall and stream, walking trails, and playgrounds.

River City

A Nickname

Columbia is sometimes called the **River City**. Can you guess why?

Marvelous Monikers

Columbia: DRAMATIC DAYS

A BIG Decision

After the 1860 presidential election, the South Carolina General Assembly called for a Secession Convention, which initially met in the First Baptist Church in Columbia. On the first day of the convention—December 17, 1860—the attendees passed a unanimous resolution to secede from the Union. Although the convention was then moved to Charleston (because of a concern about a smallpox outbreak), the initial vote cast in this Columbia church was eventually carried out.

A HUGE Loss

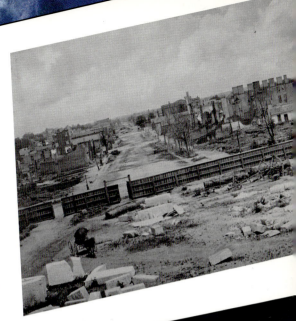

On February 16, 1865, as the Civil War was drawing to a close, Major General William Tecumseh Sherman marched his troops into Columbia. By early in the morning of February 17, fires were burning throughout the city. By Friday morning, February 18, much of Columbia lay in burnt ruins.

A NEW Park!

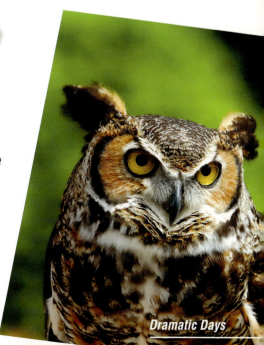

On November 10, 2003, Congaree Swamp National Monument (just 20 miles from downtown Columbia) was declared Congaree National Park—and became South Carolina's first national park. This amazing forest includes some of the tallest trees in the eastern United States, and it provides habitats for many species of plants and animals—including Great Horned Owls!

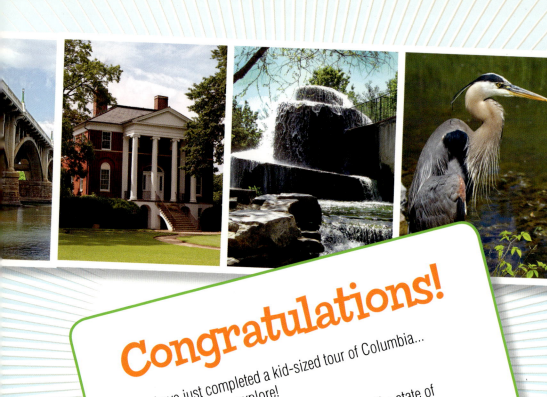

Congratulations!

You have just completed a kid-sized tour of Columbia... but there's more to explore!

The city of Columbia is an important part of the state of South Carolina. Why? It's because the city helps shape the state and the state helps shape the city!

Read on to find out more...

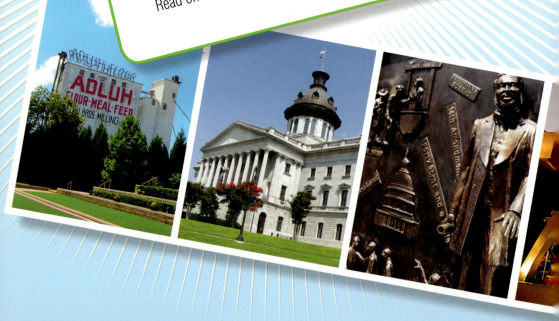

South Carolina

What's So Great About This State?

There is a lot to see and celebrate...just take a look!

CONTENTS
Land .pages 2–9
History. .pages 10–17
People .pages 18–25
And a Lot More Stuff!pages 26–31

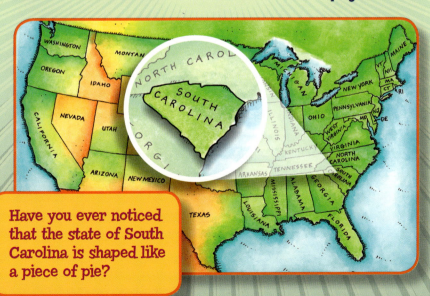

Have you ever noticed that the state of South Carolina is shaped like a piece of pie?

What's So Great About This State?
Well, how about...
The Land!

Lowcountry

The Atlantic Ocean! That's what borders the whole east side of the state of South Carolina. The land closest to the ocean begins the Coastal Plains. The northeastern part of the Coastal Plains includes the Pee Dee region which is named after a Native American tribe. The southeastern part of the Coastal Plains is called the Lowcountry because...well, it's really LOW! The land in the Lowcountry isn't much higher than the level of the water in the Atlantic Ocean.

The Coastal Plains cover about two-thirds of the state. Sandy beaches and marshes near the ocean soon give way to pine trees and rolling hills. Rivers snake up through the middle of the state (known as the Midlands, of course!) as the land slowly starts to rise. But paddling in a canoe to the northwestern part of the state will get you only so far...

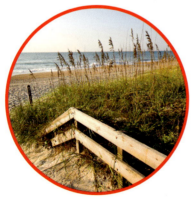

Sand dunes make a natural barrier between water and land.

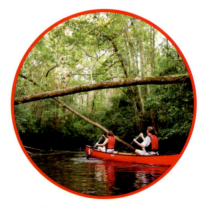

Travelers paddle through a river in the Coastal Plains.

Upcountry

…Why? It's because the upper part of South Carolina is quite a different area! The Piedmont area rises up to meet the base of the Blue Ridge Mountains. Waterfalls, forests, and lakes dot the Upcountry. Fast-moving water travels from the high mountains down through the Piedmont area. A special area—the Fall line—forms where the Upcountry rivers "fall" into the Coastal Plains. And what's at the Fall line? You guessed it—more waterfalls!

It's quite an adventure to explore the land across South Carolina. Take a closer look at the next few pages to see just some of the interesting places you can visit!

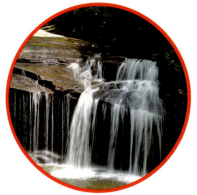

Table Rock State Park waterfall

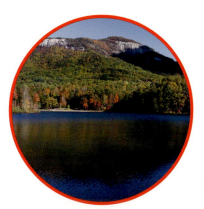

Table Rock Mountain in the Upcountry of South Carolina

Falls on Lake Jocassee

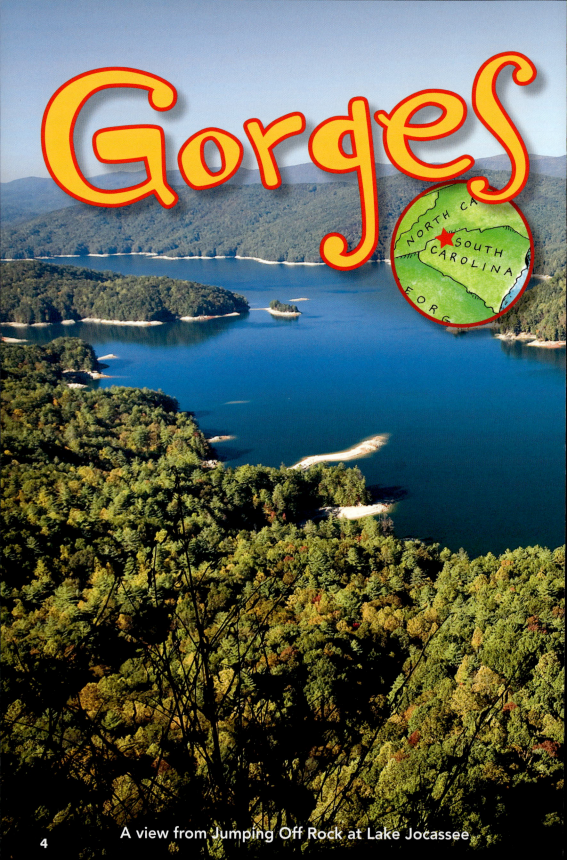

Gorges

A view from Jumping Off Rock at Lake Jocassee

Gorges are found only in the Upcountry part of the state—and in South Carolina, the gorges are known as the Jocassee Gorges. These gorges cross the border of South Carolina and extend northward into North Carolina.

Why are the Jocassee Gorges special? (...and what exactly is a gorge, anyway?)

Glad you asked! A gorge is like a canyon...only smaller! It is a deep and narrow valley with steep rocky sides...and it often has a river or a stream flowing through it.

Over a long, long period of time, mountain streams and rivers flowing down from the Blue Ridge Mountains carved a path through the rocky cliffs of this area. The Jocassee Gorges formed and this area is now protected—which means these wonderful natural resources should be around for quite a while.

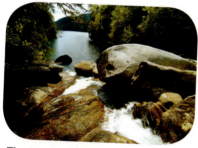

The Lower Whitewater Falls

What kind of things can I see at the Jocassee Gorges?

You can see rushing waterfalls, fast-moving rivers, and beautiful Lake Jocassee. The Gorges are also home to many different creatures, including wild turkeys, brook trout, and lots of white-tailed deer.

Don't forget the black bears!

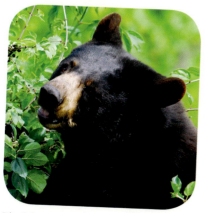

Black bears roam in Jocassee Gorges

Even though you probably won't see any (because these bears generally stay away from humans!) the Jocassee Gorges area does have one of the largest black bear populations in the Southeast. Why do bears hang out there? One reason is that this forest area is rich in berries and nuts—which black bears love to eat!

Beaches and Barrier Islands

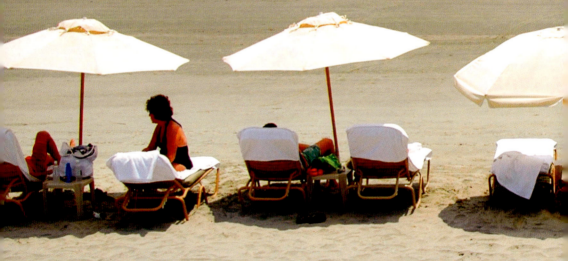

Umbrellas on the beach at Kiawah Island

Since the Atlantic Ocean borders South Carolina, the whole east coast of the state is loaded with beaches!

Why are the beaches and barrier islands so special?

If you've ever caught a wave in the water or found a shell in the sand you already know why beaches are special. And barrier islands? Well, their name says it all!

Barrier islands protect the mainland coast by providing a block, or "barrier", against wind and ocean waves. The beaches and barrier islands also protect the salt marsh nurseries along the coast. Why is this important? The nurseries are where countless young sea creatures are born or hatched every year!

What can I see at beaches and barrier islands?

Water, sand, beaches, and shells for sure! And of course, the birds! Brown pelicans dive into the water. Seagulls screech in the sky above. Stately herons and egrets stand tall in the marshes.

If you're lucky, you might spot some dolphins!

These graceful creatures often jump above the waves. Sometimes they are feeding on shrimp. Other times, they seem to be just playing on the waves!

Dusk at Hilton Head beach

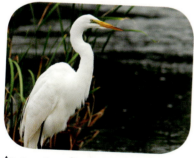

An egret wading at Huntington Beach State Park

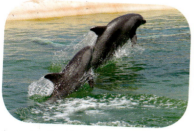

Jumping bottlenose dolphins

Lake Wateree at Dusk

Natural and human-made lakes can be found throughout the state. And since water flows downhill, there are plenty of rivers moving from higher to lower ground in South Carolina.

Why are the lakes and rivers so special?

Lakes and rivers provide recreation, transportation, food, and habitats! Interestingly enough, several large lakes in the state weren't formed by nature but were made by people. Dams built on major South Carolina rivers in the 1930s and 1940s backed up river water. This flooded the land that now lies under Lake Marion, Lake Moultrie, and Lake Murray.

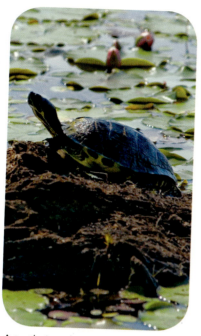

A turtle is at home on the lake.

What can I see at the lakes and rivers?

Bullhead, bass, and bream! Is it the name of a new restaurant? Nope...these are the names of some of the different kinds of fish swimming in South Carolina lakes and rivers.

What's a blackwater river and why is the water so dark?

Fast-moving whitewater rivers flow from the Uplands down through the Piedmont. But blackwater rivers move more slowly through spooky-looking swamps and soggy wetlands of the Coastal Plains. The Edisto River is the longest free-flowing blackwater river in the United States! It twists and turns more than two hundred miles through the state.

Tons of leaves and other plant parts fall into the rivers to rot. Stuff (called tannins) from the decaying plant material turns the river water dark in color.

The Edisto River is a long blackwater river!

What's So Great About This State?

Well, how about...
The History!

Tell Me a Story!

The story of South Carolina began thousands of years ago. Following the tradition of their ancestors who first lived on the land, Native Americans made their homes throughout the state. Most lived in groups called tribes and descendants from many tribes still live in the state today.

You often hear people speak of these Native American tribes because many places throughout the state are named in their honor. The Edisto River, the Pee Dee River, Oconee State Park, Santee State Park—these names all honor the groups of people who first lived on this southeastern land so long ago.

This statue honors the Cassique, or Chief, of the Kiawah tribe who welcomed the first permanent English settlers to the historic site now called Charles Towne Landing.

...The Story Continues

Eventually, South Carolina became home to many other groups, including Spanish explorers, European American settlers, and African Americans. Many battles for independence were fought in South Carolina—but history isn't always about war. South Carolinians have always educated, invented, painted, written, sung, and built. Many footprints are stamped into the soul of South Carolina's history. You can see evidence of this all over the state!

South Carolina is an original! As one of the original 13 colonies, the state had a strong presence in the Revolutionary War.

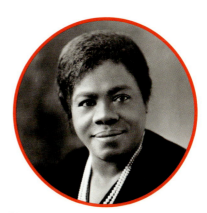

Mary McLeod Bethune was an educator and civil rights leader who was born in Mayesville, SC.

Oconee Station State Historic Site

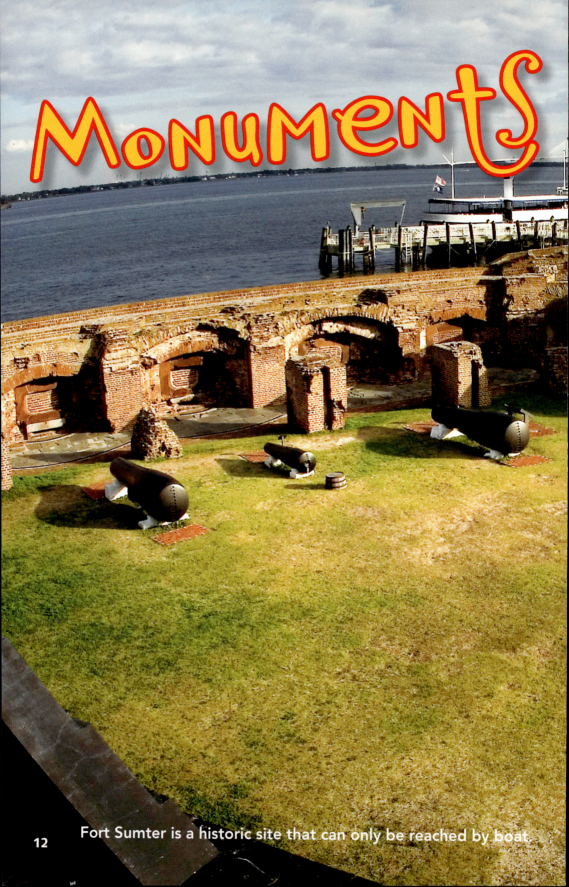

Monuments

Fort Sumter is a historic site that can only be reached by boat.

Monuments honor special people or events. Fort Sumter is a national monument located at the entrance of the harbor of Charleston, South Carolina. The fort is named for a South Carolina Revolutionary War hero, but it is known as the place where the first shots of the Civil War were fired.

Why are South Carolina monuments so special?

That's an easy one! The hundreds of monuments (and memorials) throughout the state honor soldiers, poets, politicians, and "extraordinary" ordinary people who helped shape both the state of South Carolina and the nation.

What kind of monuments can I see in South Carolina?

There are statues, plaques, markers, cornerstones, bridges, named streets—almost every town has found some way to honor a historic person or event.

Where are monuments placed?

Anyplace where something important happened! For example, during the Revolutionary War, a cow pasture in Cowpens, South Carolina was turned into a battlefield. Today that pasture is preserved as a national historic site known as the Cowpens National Battlefield.

The picture shows a monument that honors the Tuskeegee airmen. These African American pilots were respectfully nicknamed the "Red Tail Angels" for their bravery in flight.

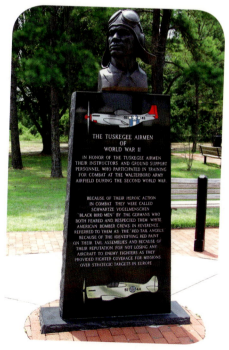

This marker honors the Tuskeegee Airmen and those who helped train them for combat at the Walterboro, SC Army Airfield during World War II.

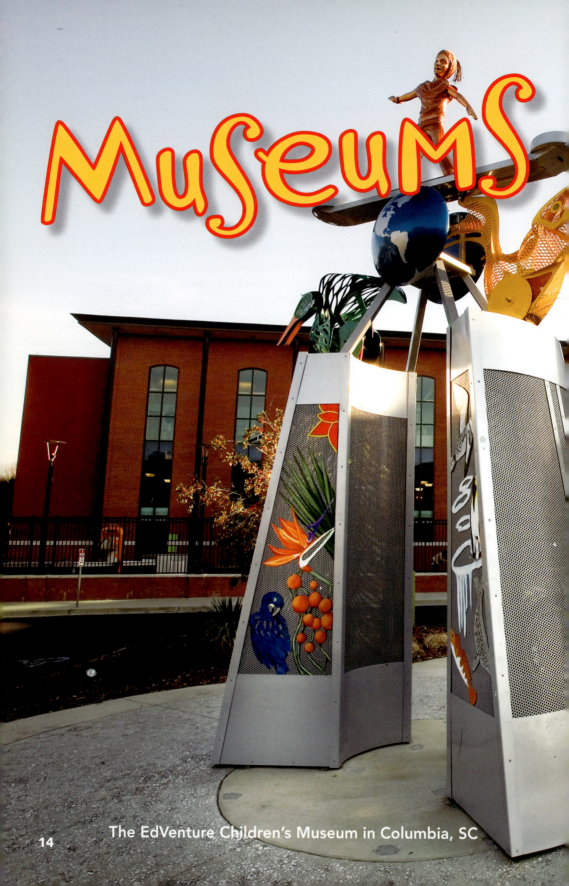

Museums

The EdVenture Children's Museum in Columbia, SC

Museums don't just tell you about history—they actually show you artifacts from times past. Artifacts can be actual objects or models of objects—either way, they make history come alive!

Why are South Carolina's museums so special?

South Carolina's museums contain amazing exhibits with artifacts that tell the story of the state. In fact, the State Museum in Columbia is actually an artifact itself! The museum is housed in what was once the world's first all-electric textile mill.

Some museums even float!

At the Patriots Point Naval and Maritime Museum you can actually climb onto the USS Yorktown (CV-10) aircraft carrier. This huge ship is the length of three football fields and was once home to 3,000 sailors!

What can I see in a museum?

An easier question to answer might be "What *can't* I see in a museum?" There are thousands of items exhibited in all kinds of different museums across the state. Do you want to know about the state's insects? The Clemson University Arthropod Collection has over one hundred thousand invertebrates on display! Or perhaps you are interested in stock car racing? Then the Joe Weatherly Museum in Darlington, South Carolina is the place to visit!

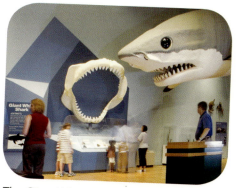

The Giant White Shark exhibit at the South Carolina State Museum

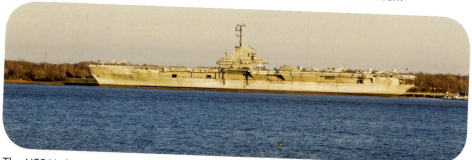

The USS Yorktown at the Patriots Point Naval Museum in Mt. Pleasant, South Carolina once played a big role in World War II.

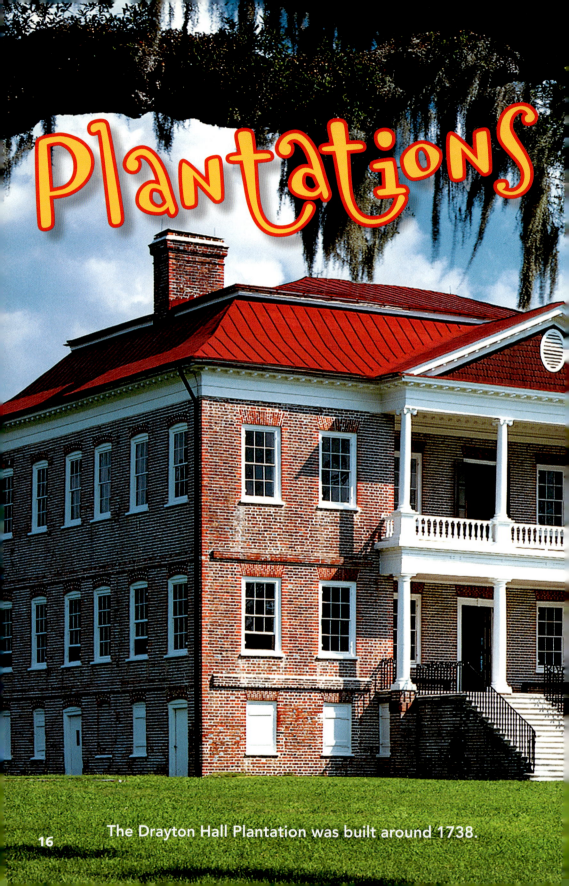

Plantations

The Drayton Hall Plantation was built around 1738.

The Drayton Hall Plantation is preserved in its nearly original condition. What does that mean? It means that it has no electricity, no plumbing, no heating, and no air conditioning!

Why are plantations special? (....and what is a plantation, anyway?)

Plantations were large estates or farms where crops such as rice and cotton were grown. Enslaved Africans, and, later, enslaved African Americans, did most of the work on a plantation.

Today, many plantations tell the shared history of our country. All have fascinating stories of race, culture, families, and sacrifice.

What can I see if I visit a plantation?

Some plantations show you what life was like hundreds of years ago. You can still see the work of many enslaved people who became skilled blacksmiths and coopers. (A cooper is someone who makes all the different containers, such as barrels and buckets, used on a plantation.)

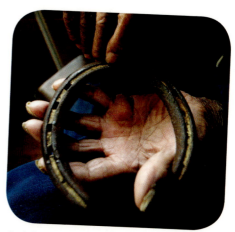

A skilled blacksmith shows a horseshoe.

...and there's more!

Other plantations today grow beautiful gardens and produce real food crops. The Silver Bluff Plantation in Aiken, SC is now owned by the Audubon Society. This plantation is a wildlife sanctuary…it provides a protected home for many birds such as bald eagles, wood storks, and red-headed woodpeckers.

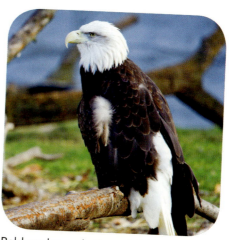

Bald eagles and other wildlife are protected at The Silver Bluff Plantation in Aiken.

What's So Great About This State?

Well, how about...
The People!

Enjoying the Outdoors

More than four million people live in the state of South Carolina. Though they have different beliefs and different traditions, South Carolinians have plenty in common.

Most share a love of nature. Because South Carolina has such a mild climate, people are able to enjoy the outdoors all year long. Surfing, golfing, hiking, boating, fishing, swimming—the list of things that South Carolinians enjoy goes on and on! Since the natural environment is so important to South Carolinians, most feel a shared responsibility to take care of it.

Casting a net in a tidal creek might bring in blue crab or shrimp.

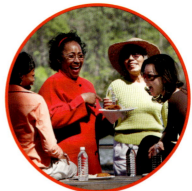

Sesquicentennial Park in Columbia is a good place to picnic with friends.

Sharing Traditions

The people of South Carolina share the freedom to celebrate different heritages. Enslaved people brought to South Carolina from West Africa and the West Indies were not allowed to speak their own languages. So they developed a new one—called Gullah—which is a combination of English and African words. The Gullah culture is still alive today and preserves many rich traditions.

Did you ever wonder what a Civil War battle was like? South Carolinians often re-create battles to honor the history and heritage of brave soldiers. Cooking is another way to pass on traditions. Great Southern food recipes are cherished family keepsakes!

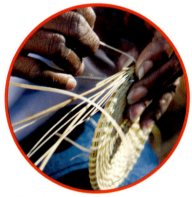

Weaving sweetgrass baskets is one Gullah tradition that has become a well-respected art.

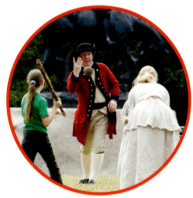

A ball game at Andrew Jackson State Park offers the chance to celebrate both the old and the new.

Fishing at Hickory Knob State Resort Park

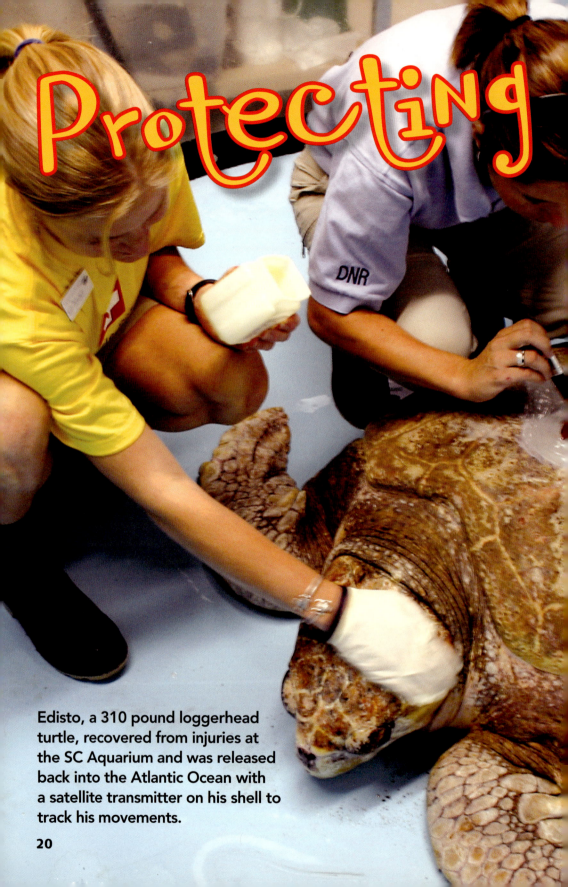

Protecting

Edisto, a 310 pound loggerhead turtle, recovered from injuries at the SC Aquarium and was released back into the Atlantic Ocean with a satellite transmitter on his shell to track his movements.

Protecting all of South Carolina's natural resources is a full time job for many people!

Why is it important to protect South Carolina's natural resources?

The state of South Carolina is only about two hundred miles wide, but you'll find a lot of different environments within its borders. Going inland from the coast, the land changes from coastal marshes and blackwater rivers to mountain forests and whitewater falls. All these different environments mean many different kinds of plants and animals can live throughout the state. In technical terms, South Carolina has great biodiversity! This biodiversity is important to protect because it keeps the environments balanced and healthy.

The Oconee Bell is a rare flower in the wild. But it is one of the first spring blooms in Devils Fork State Park.

What kinds of organizations protect these resources?

It takes a lot of groups to cover it all. The U.S. Fish and Wildlife Service is a national organization. The SC Department of Natural Resources and the SC State Parks Service are state organizations. Of course, many smaller groups exist as well. The Center for Birds of Prey in Awendaw, South Carolina treats nearly four hundred injured birds each year!

A state park ranger talks to kids about a forest habitat.

And don't forget...

You can make a difference, too! It's called "environmental stewardship" and it means that you are willing to take personal responsibility to help protect South Carolina's natural resources. It's a smart choice for a great future!

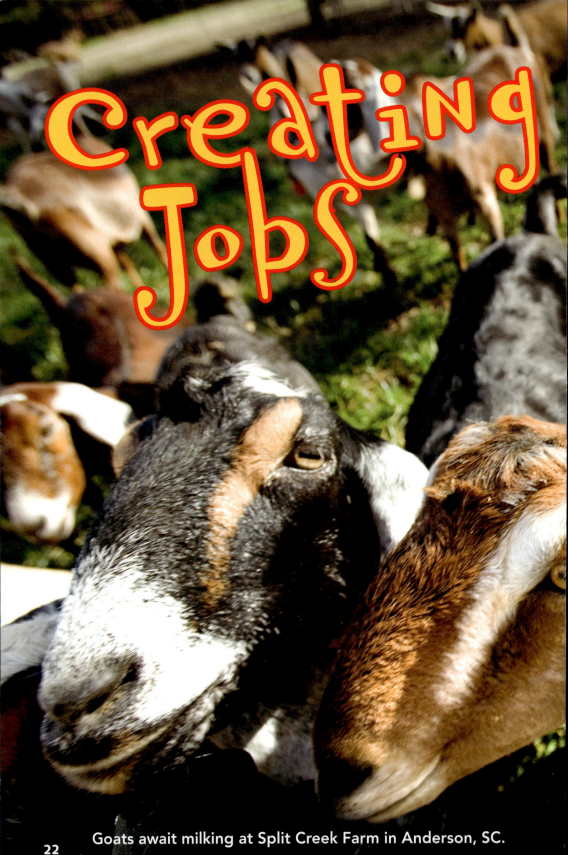

Creating Jobs

Goats await milking at Split Creek Farm in Anderson, SC.

Although Georgia is known as the Peach State, South Carolina grows more peaches.

Some jobs, such as growing cotton, have been around since the state was first formed. Other jobs, such as film-making, are new and growing in demand.

Why is South Carolina a good place for business?

The land and the people make a good combination for a variety of businesses throughout the state.

What kinds of jobs are available throughout the state?

South Carolinians have always been good at making things. Today, many people work in the manufacturing industry. From fabric and cars to chemicals and paper, great products come through warehouses all over the state.

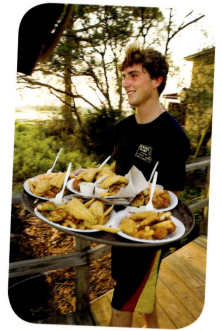

Service work is plentiful in the state.

Farming has always been important to the state. Another big industry is the service industry. It's growing in large part because millions of tourists travel through the Palmetto State each year. Many jobs are needed to help people sightsee, dine, and relax!

Don't forget the military!

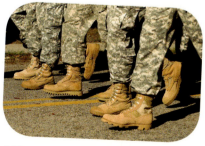

Military training is hard work!

The Air Force, Army, Marines, Navy and the Coast Guard all have a presence in the state. Whether training or working, the brave men and women who serve our country are held in great respect throughout South Carolina.

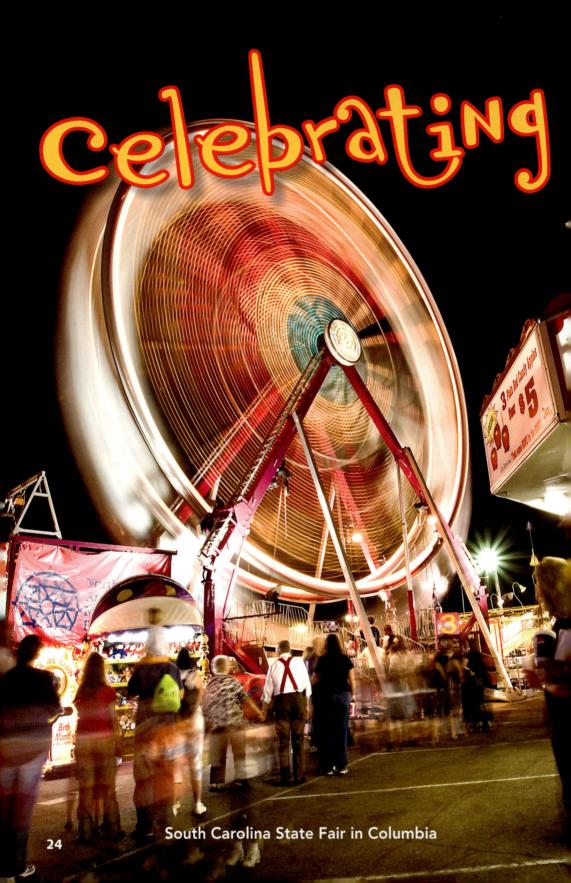

South Carolina State Fair in Columbia

The people of South Carolina really know how to have fun! The State Fair draws tens of thousands of people to the capital city of Columbia each year.

Why are South Carolina festivals and celebrations special?

Celebrations and festivals bring people together. From cooking contests to surfboarding, events in every corner of the state showcase all different kinds of people and talents.

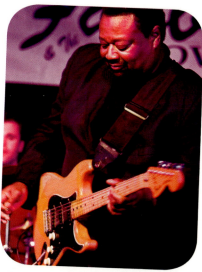

Chef Barry "Fatback" Walker cooks at a great restaurant in Columbia. He also plays jazz music on his guitar!

What kind of celebrations and festivals are held in South Carolina?

Too many to count! But one thing is for sure, you can find a celebration or festival for just about anything you want to do. Do you like to eat peaches? Gaffney has held a Peach Festival every year for more than thirty years.

Do you like to watch car races? Stock cars speed around the Darlington racetrack at more than 180 miles per hour. Want to hear some great music? Try the Main Street Latin Festival in Columbia or the Spoleto Festival in Charleston!

Don't forget about the Governor's Frog Jump Contest!

Yes, it's true! For more than forty years there has been a frog jumping contest in Springfield, South Carolina. The winner gets to go to the Calaveras County Frog Jump in California which honors a story written by Mark Twain in the 1800s.

The Atalaya Festival at Huntington Beach State Park showcases amazing artwork in a beautiful outdoor location.

Birds and Words

What do all the people of South Carolina have in common? These symbols that represent the state's shared history and natural resources.

State Bird
Carolina wren

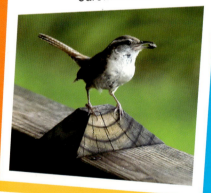

State Flower
Yellow jessamine

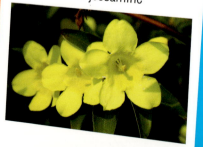

State Tree
Palmetto

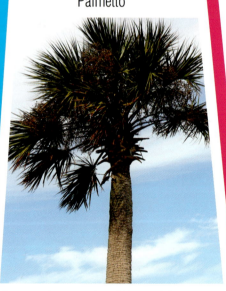

Can a tree be a state hero? You bet! The palmetto tree helped South Carolinians defeat the British in 1776 during the Revolutionary War. Fort Moultrie was built of sand and palmetto wood. When the British took aim at the fort, the spongy walls absorbed most of the enemy fire!

State Fruit
Peach

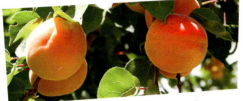

There are more than 30 varieties of peaches in South Carolina. How many have you tried?

State Flag
Adopted in 1861

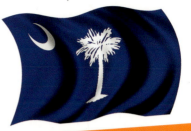

State Reptile
Loggerhead sea turtle

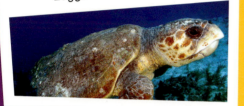

State Gem
Amethyst

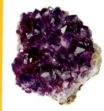

One of the most beautiful pieces of amethyst comes from South Carolina! It's on display at the American Museum of Natural History in New York City.

State Animal
White-tailed deer

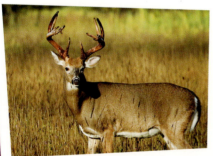

State Butterfly
Eastern tiger swallowtail

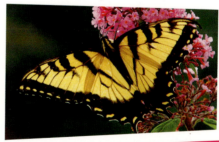

Want More?

Statehood—May 23, 1788
State Capital—Columbia
State Nickname—Palmetto State
State Song—"Carolina"
State Insect—Carolina mantid
State Game Bird—Wild turkey
State Spider—Carolina wolf
State Shell—Lettered olive
State Stone—Blue granite
State Beverage—Milk
State Dance—The shag

More Fun Facts

More
Here's some more interesting stuff about South Carolina!

The Dotted Line
At 26, Edward Rutledge of Charleston was the youngest signer of the Declaration of Independence.

Fit For a King
The state of South Carolina was named after King Charles I of England.

Battlefield
More than 125 Revolutionary War battles were fought on South Carolina soil.

Rooted in History
The "Avenue of Oaks" at Boone Hall Plantation in Mt. Pleasant, SC was started in 1843. More than 160 years later, the 88 oak trees, draped in Spanish moss, form a spectacular sight that stretches for three-quarters of a mile.

The Great Outdoors
South Carolina has 4 state forests and 47 state parks.

Nice Digs!
The beautiful Edisto Memorial Gardens has earned Orangeburg the title of the "Garden City".

Lights, Camera, Action
Some movies made in South Carolina include Forrest Gump, Ace Ventura, Cold Mountain, Die Hard with a Vengeance, and That Darn Cat.

Gritty
A landmark since the early 1800s, the restored Golden Creek Mill near Easley still uses a water wheel to power the old milling equipment inside.

Fore!
Myrtle Beach is the "Miniature Golf Capital of the World." There are about 50 courses, including ones with dinosaurs, pirates, airplanes, dragons, and fire-spewing volcanoes.

Original Recipe
Frogmore stew originated near Beaufort. This one pot meal usually contains seasoned sausage, shrimp, corn, and potatoes.

Big Blocker
The Dreher Shoals Dam (that formed Lake Murray) is still one of the largest earthen dams in the United States.

Tick Tock
Built back in the 1830s, the town clock in Winnsboro is thought to be the longest continuously running town clock in the nation.

Gotcha Covered
Campbell's Covered Bridge, near Gowensville, is the only remaining covered bridge in the state.

What a Peach
It took 50 gallons of paint to turn a million-gallon water tower in Gaffney into a giant peach with a 12-foot stem and a 60-foot leaf.

Small to Large
There are 46 counties in South Carolina. The smallest county in South Carolina is McCormick and the largest county is Horry.

What a View!
From Sassafras Mountain, the state's highest point, you can see Tennessee, North Carolina, and Georgia.

A Walk in the Park
Cheraw State Park in Chesterfield County was founded in 1934 and is South Carolina's oldest state park.

Do You Have the Time?
Barnwell's 150-year-old vertical sundial is the only one of its type in the country. It stays within minutes of standard time.

A Celebrated Fruit
The Hampton County Watermelon Festival is the oldest continuously held festival in the state. It began in 1939.

Plowed Over
The Darlington Raceway was once an old cotton and peanut field.

Find Out More

There are many great websites that can give you and your parents more information about all the great things that are going on in the state of South Carolina!

State websites

The Official Web Site of the State of South Carolina
www.sc.gov

South Carolina State Parks
www.southcarolinaparks.com

The Official Tourism Site of South Carolina
www.discoversouthcarolina.com

Museums/Columbia

South Carolina State Museum
www.museum.state.sc.us

Columbia Museum of Art
www.columbiamuseum.org

Charleston

The Charleston Museum
www.charlestonmuseum.org

Children's Museum of the Lowcountry
www.explorecml.org

Darlington

Joe Weatherly Museum, NMPA Stock Car Hall of Fame
www.autospeak.com/museum03.htm

Gaffney

Cherokee Historical & Preservation Society, Inc.
www.cherokeecountyhistory.org

Greenville

Upcountry History Museum
www.upcountryhistory.org

Hilton Head

Coastal Discovery Museum
www.coastaldiscovery.org

Myrtle Beach

South Carolina Hall of Fame
www.theofficialschalloffame.com

Children's Museum of South Carolina
www.cmsckids.org

Aquariums and the Zoo

South Carolina Aquarium (Charleston)
www.scaquarium.org

Riverbanks Zoo (Columbia)
www.riverbanks.org

Ripley's Aquarium (Myrtle Beach)
www.ripleysaquarium.com

South Carolina: At A Glance

State Capital: Columbia

South Carolina Borders: Atlantic Ocean, Georgia, North Carolina

Population: Over 4 million

Highest Point: Sassafras Mountain is 3,560 feet (1085 meters) above sea level

Lowest Point: Sea level on the coastline

Major Cities: Columbia, Charleston, North Charleston, Greenville, Rock Hill

Some Famous South Carolinians

John C. Calhoun (1782-1850) from around Abbeville, SC; was an American senator and political philosopher.

Mary McLeod Bethune (1875-1955) from Mayesville, SC; was an educator and president of a college for young African American women.

Mary Boykin Miller Chestnut (1823-1886) from Statesboro, SC; was a writer who recorded her Confederate experiences in a series of famous diaries.

May Craig (1889-1975) from Coosaw, SC; was a female journalist who reported from the front lines of battle during World War II.

Althea Gibson (1937-2003) from Silver, SC; was the first African American woman to win both Wimbledon and the U.S. National Championship in tennis.

Dizzy Gillespie (1917-1993) from Cheraw, SC; was a famous jazz trumpet player, bandleader, and composer.

Andrew Jackson (1767-1845) from Waxhaw, SC; became the seventh president of the United States.

Francis Marion (1732-1795) from Berkeley County, SC; was called the Swamp Fox as a commander in the American Revolutionary War.

Ronald McNair (1950-1986) from Lake City, SC; was an astronaut for NASA who received the Congressional Space Medal of Honor.

Charles Hard Townes (born 1915) from Greenville, SC; is a scientist who won the 1964 Nobel prize in physics.

Darius Rucker (born 1966) from Charleston, SC; is a Grammy-winning singer and guitarist.

Fishing at Hickory Knob State Resort Park

CREDITS

Series Concept and Development
Kate Boehm Jerome

Series Design
Steve Curtis Design, Inc. (www.SCDchicago.com); Roger Radtke, Todd Nossek

Reviewers and Contributors
Stacey L. Klaman, writer and editor, San Diego, CA
Marc Rapport, Manager Media Relations, SC Department of Parks, Recreation & Tourism

Photography
Back Cover(a,b), Back Cover(d,e), Cover(e), 2-3, 2(a), 2(b), 3(a), 3(b), 4-5, 5(a), 7(b), 8-9, 9(a), 9(b), 10-11, 10, 12-13, 14-15, 17(a), 18-19, 18(a,b), 19(a,b), 21(a,b), 22-23, 23(a), 24-25, 25(a,b), 26(c), 32 © Perry Baker/SCPRT; Back Cover(c), 26(b) © Cathy Luckhart/Shutterstock; Cover(a) © Lawrence Cruciana/Shutterstock; Cover(b,c), 6-7 © Jason Tench/Shutterstock; Cover(d), 7(a) © July Flower/Shutterstock; Cover(f) © iofoto/Shutterstock; Cover(g) © Steven Faucette; 5(b) © nialat/Shutterstock; 7(c) © Henry William Fu/Shutterstock; 11(a) © n4 PhotoVideo/Shutterstock; 11(b) © Scurlock, Archives Center, National Museum of American History, Smithsonian Institution; 13 © Michael Stroud; 15(a) © Susan Dugan/South Carolina State Museum; 15(b) © Condor 36/Shutterstock; 16-17 © Ron Blunt/Drayton Hall; 17(b) © Alexey Stiop/Shutterstock; 20-21 © South Carolina Aquarium; 23(a) © Apollofoto/Shutterstock; 23(c) © John Wollwerth/Shutterstock; 26(a) © Benjamin F. Haith/Shutterstock, 27(a) © Larry Ye/Shutterstock; 27(b) © Carsten Reisinger/Shutterstock; 27(d) © Marco Cavina/Shutterstock; 27(e) © Bruce MacQueen/Shutterstock; 27(c) © Craig Hosterman/Shutterstock; 28 © Terence Mendoza/Shutterstock; 29(a) © Dewitt/Shutterstock; 29(b) © Hannamariah/Barbara Helgason/Shutterstock; 31 © R. Gino Santa Maria/Shutterstock

Illustration
Back Cover, 1, 4 © Jennifer Thermes/Photodisc/Getty Images

Copyright © 2008 Kate Boehm Jerome. All rights reserved. No part of this book may be used or reproduced in any manner without written permission except in the case of brief quotations embodied in critical articles and reviews.

ISBN 978-1-4396-0000-9
Library of Congress Catalog Card Number: 2008937172

2 3 4 5 6 WPC 15 14 13 12 11 10

Published by Arcadia Publishing
Charleston SC, Chicago IL, Portsmouth NH, San Francisco CA

For all general information contact Arcadia Publishing at:
Telephone 843-853-2070
Fax 843-853-0044
Email sales@arcadiapublishing.com
For Customer Service and Orders:
Toll Free 1-888-313-2665

Visit us on the Internet at www.arcadiapublishing.com